POLAROIDS OF WOMEN

DEWEY NICKS

T. ADLER BOOKS, SANTA BARBARA

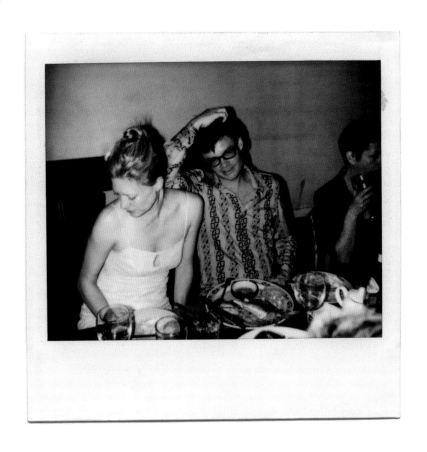

Stephanie & Dewey Nicks, Hollywood

The past is a fickle place. It feels both like yesterday and a million years ago.

In the pre-digital age, Polaroids were used to test light and composition before committing something to film. They were fast and immediate, considered utilitarian. Often dozens were shot before all was ready for the "real" camera. Most of the time those Polaroids were tossed, but Dewey saved his favorites. Others were discarded or resigned to refrigerator fronts and bankers boxes, backs of drawers, and scrapbooks. Polaroid images fade fast, they yellow and crack. They are not archival.

Dewey had great affection for stylish architecture and interiors and for a more glamorous past of classic cars and resort style living, tube amps and highballs, everything custom. When he needed locations we would brainstorm and wish list. We were both interested in iconic and, in those days, under appreciated California, Hawaii, and New York locations. A lot of the time we just used the excuse of a photo shoot to get inside places and meet people we had long admired and were still alive (i.e. Paul Rudolph's Beekman Place penthouse or Albert Frey's modernist hillside aerie in Palm Springs). Often the location would not even show up in the final edit but the inspiration and relaxation of being there sure did.

In some ways these Polaroids have more authenticity than what ultimately ran in the ads or editorials. The subjects knew when Dewey was shooting "for real" but in these Polaroids the women look more relaxed, not quite yet turning it completely "on." And being on set with Dewey is legendary. He is an old school master storyteller and impressionist, seriously one of the funniest people I have ever met. His shoots were hard work but you were very entertained. The girls loved him. He was always, every minute, fully engaged.

They are like ice cubes these memories, these Polaroids—frozen in time moments on paper, fragile, melting, fading, on their way out. They can be gorgeous, especially at this stage of their disintegration, with the chemically imperfect edges and soft Outerbridge-like muted colors. I like that he is scanning and publishing now, freezing them again at this later, different, softer stage of their lifespan, for posterity. They are as beautiful as can be and they trigger the fondest memories.

The photos may fade but memory is more permanent than ink.

– Brad Dunning

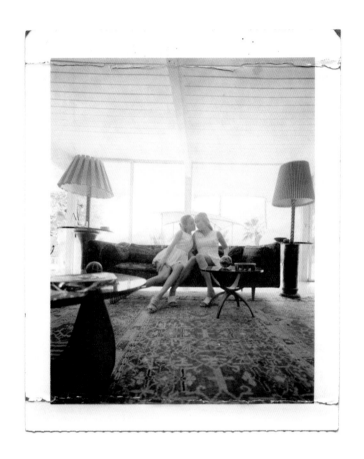

Bijou Phillips & Emily Cadenhead, Palm Springs

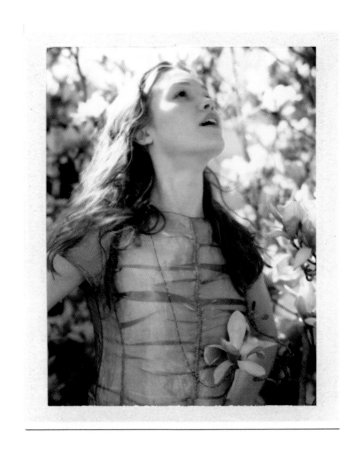

Julia Stiles, Morgan House, Hollywood

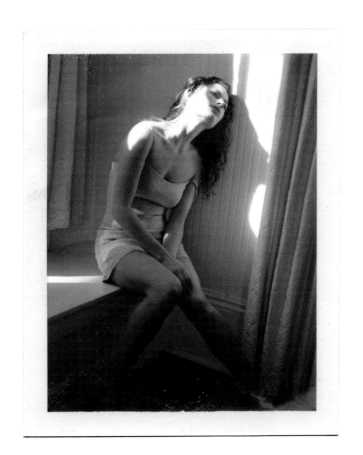

Shalom Harlow, 12th Street, New York

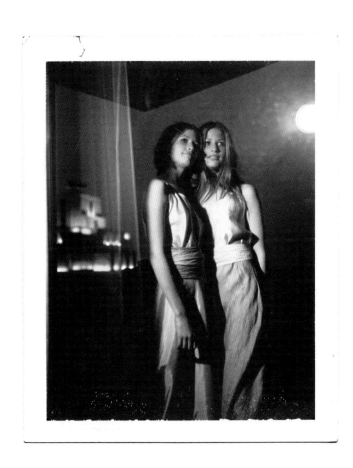

Lindsey & Amanda Lockwood, Sunset Strip, West Hollywood

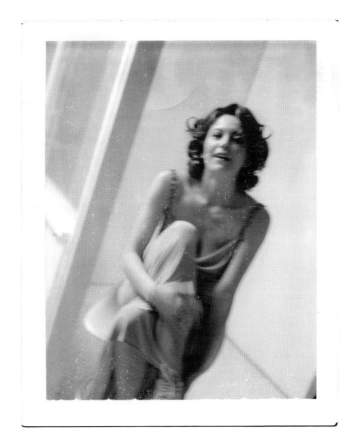

Diane Lane, Stone Canyon

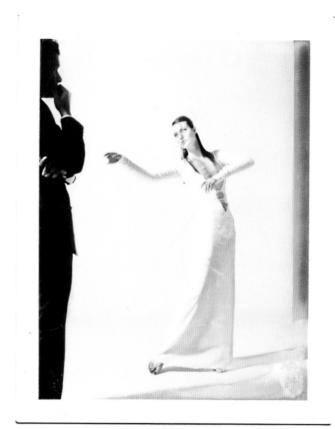

Isaac Mizrahi & Shalom Harlow, New York

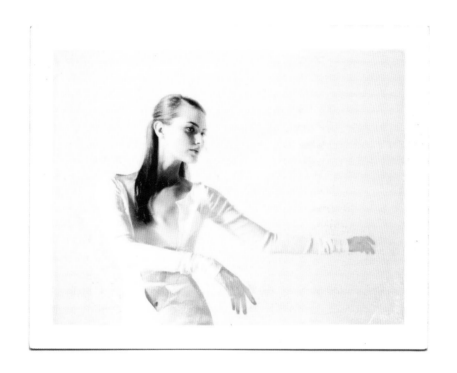

Shalom Harlow, New York

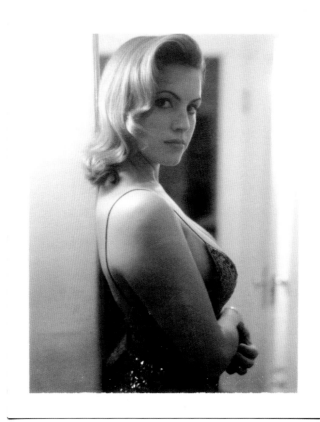

Sandra Taylor, Morgan House, Hollywood

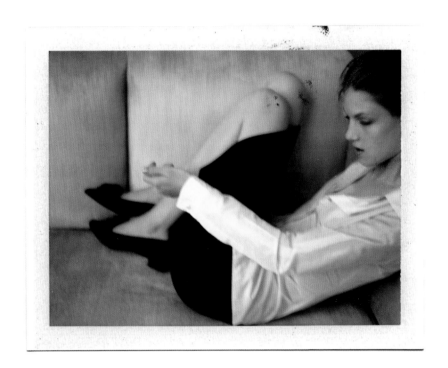

Angela Lindvall, Manhattan

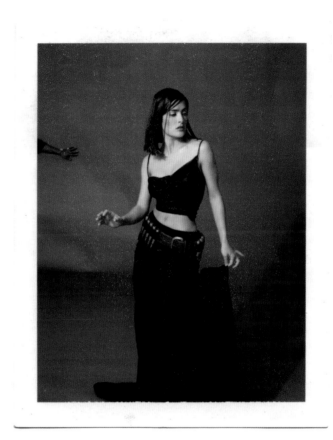

Salma Hayek, Culver City

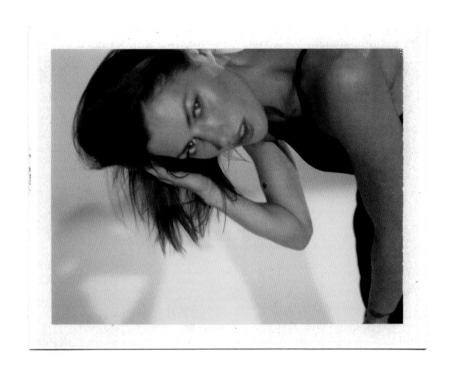

Carré Otis, New York

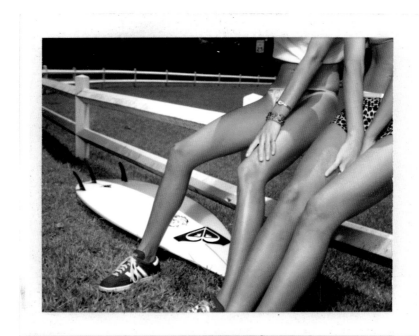

Hanalei Bay, Kauai

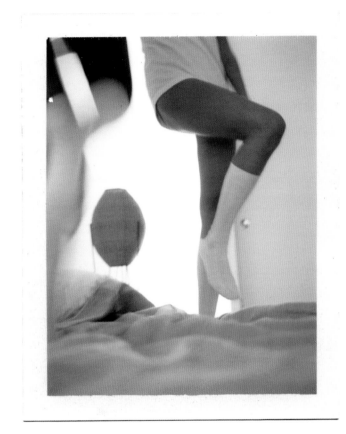

Morgan House, Hollywood

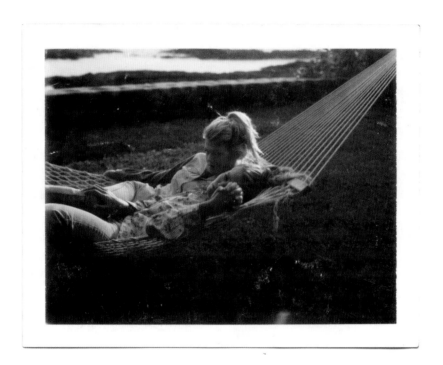

Ingrid Seynhaeve & Valeria Mazza, Kona

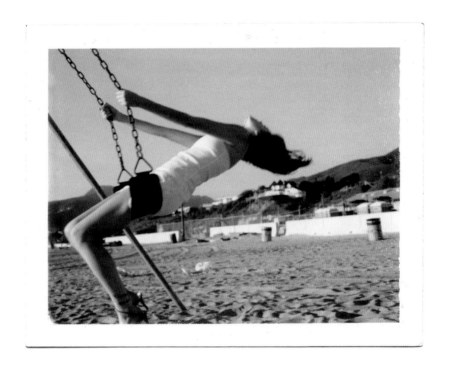

Jasmine Guinness, Zuma Beach

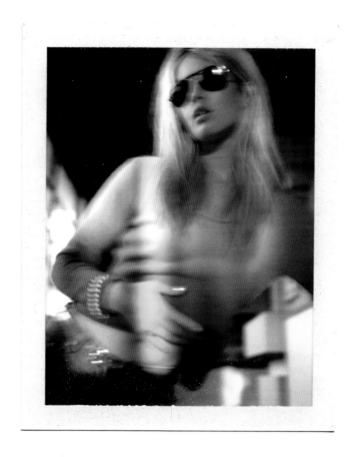

Valeria Mazza, Morgan House, Hollywood

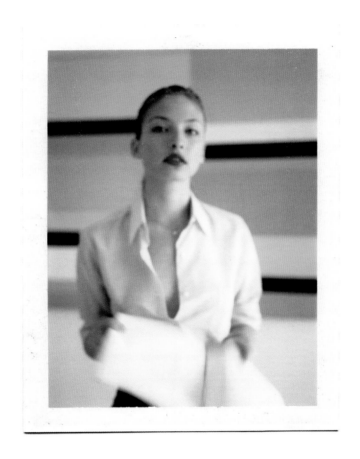

Kristina Semenovskaia, Stone Canyon

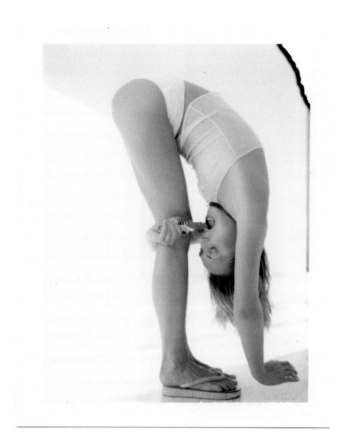

Ruza Madarevic, Wexler Steel House, Palm Springs

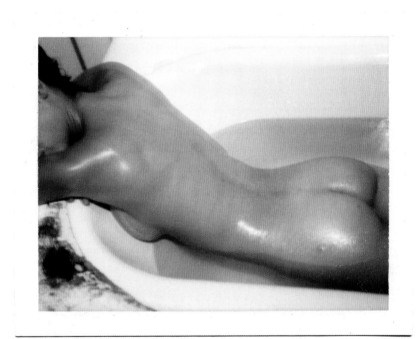

Morgan House, Hollywood

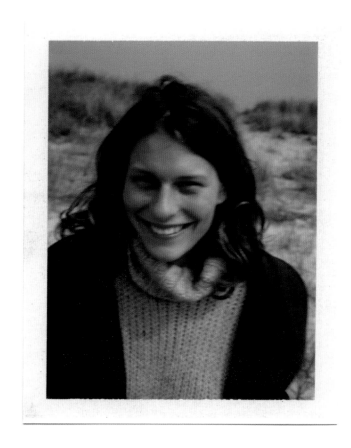

Sara Lamm, Montauk

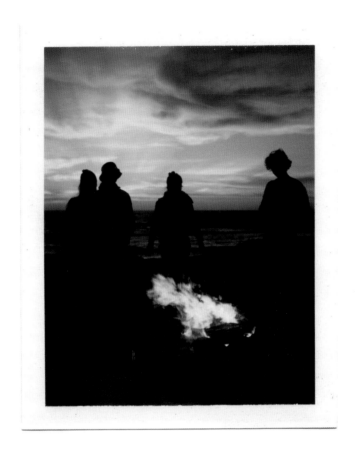

Cambria, California

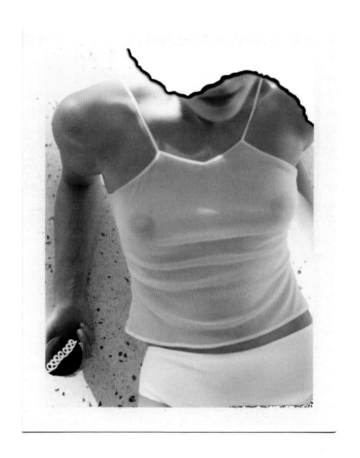

Ruza Madarevic, Wexler Steel House, Palm Springs

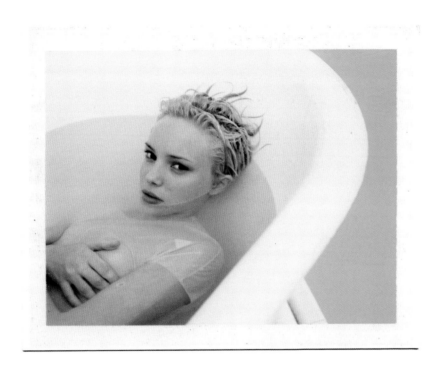

Jaime Rishar, Palm Springs

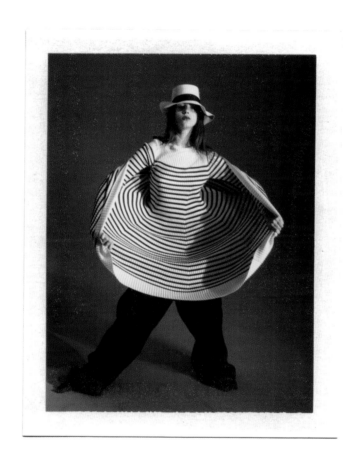

Myka Dunkle, Culver City

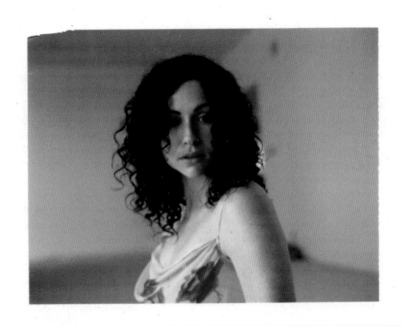

Minnie Driver, Bel Air

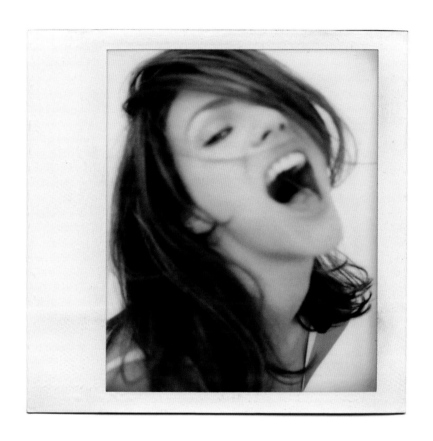

Noemi de Kwiatkowski, Manhattan

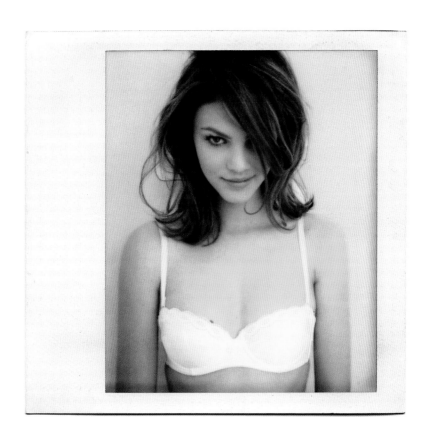

Noemi de Kwiatkowski, Manhattan

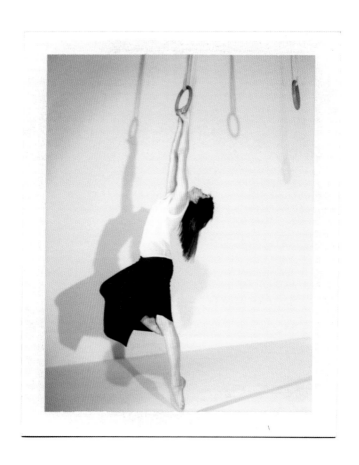

Myka Dunkle, Culver City

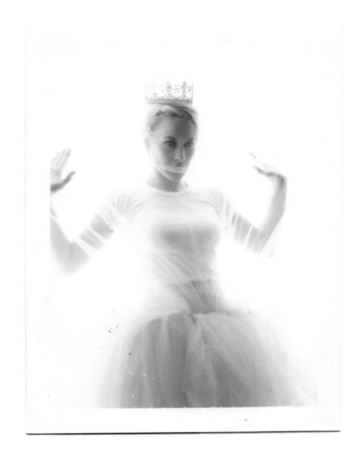

Patricia Arquette, Hollywood

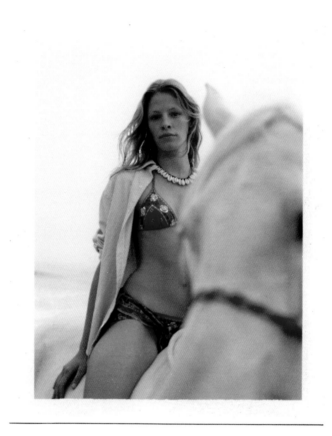

Tanga Moreau, Naples Ranch, California

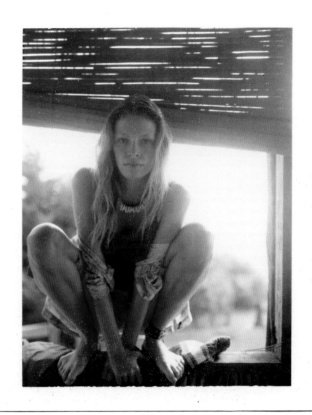

Tanga Moreau, Naples Ranch, California

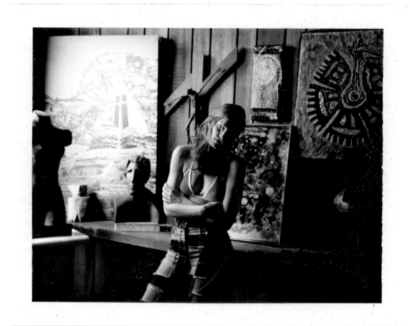

Cindy Crawford, Big Sur

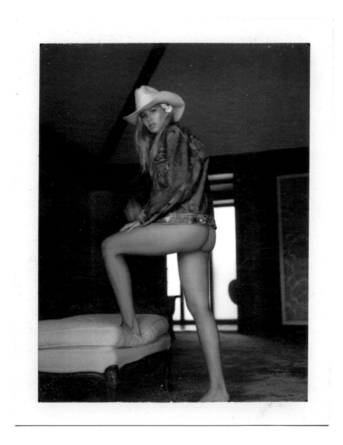

Valeria Mazza, Kona

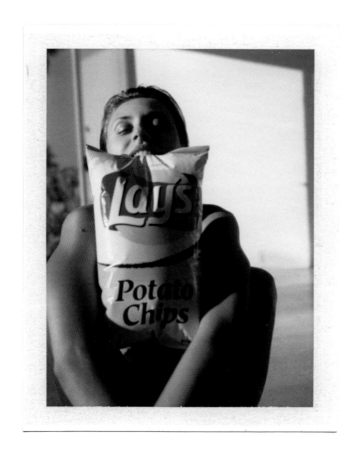

Ruza Madarevic, Wexler Steel House, Palm Springs

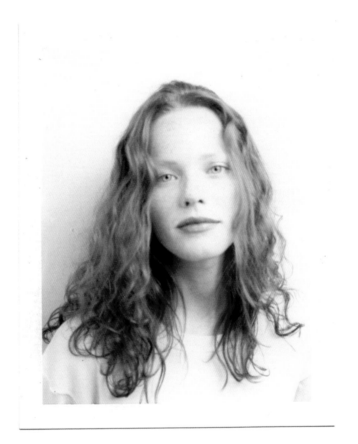

Marianne Schröder, Hollywood

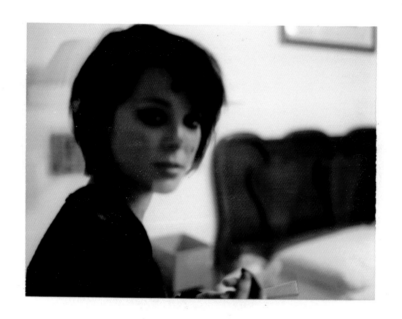

Jordan Ladd, Inglewood

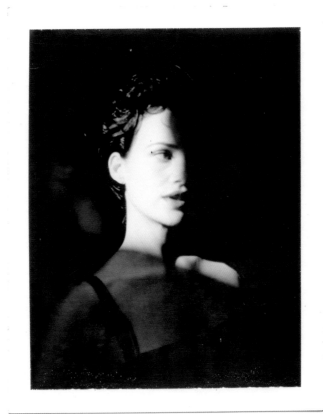

Carla Gugino, Bel Air

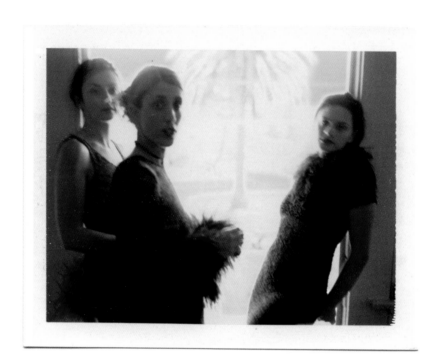

Lisa Storey, Jenny Levy & Pati Dubroff, Silver Lake

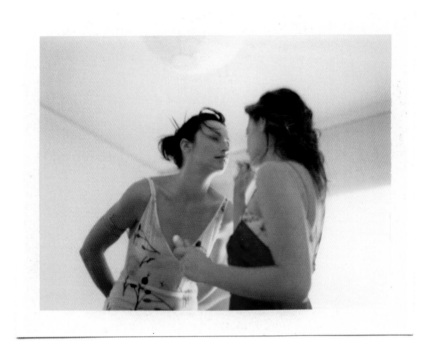

Lisa Storey & Pati Dubroff, Silver Lake

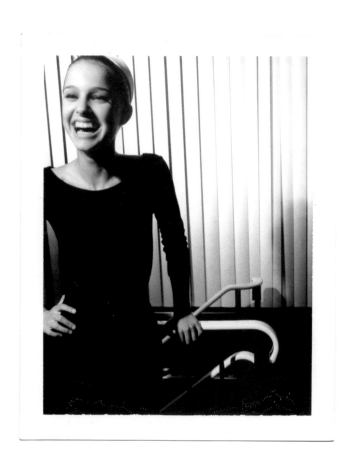

Natalie Portman, Hell's Kitchen, New York

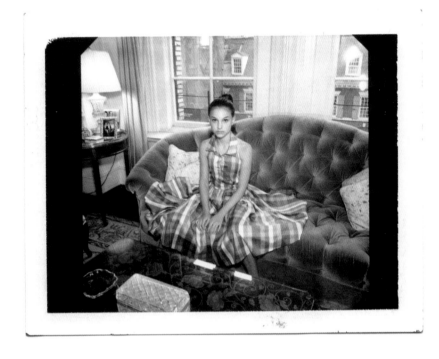

Natalie Portman, Upper East Side, New York

Elizabeth Berkley, Morgan House, Hollywood

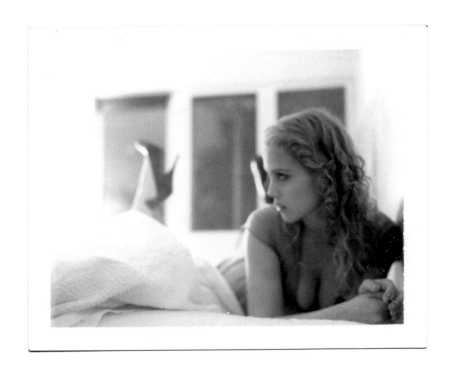

Elizabeth Berkley, Morgan House, Hollywood

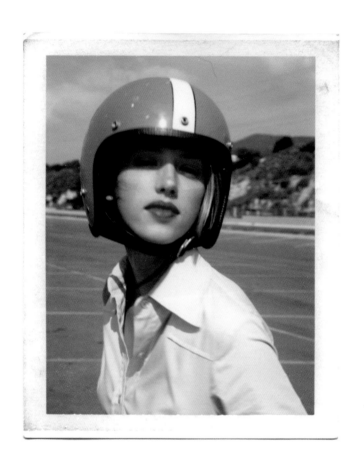

Leilani Bishop, Zuma Beach

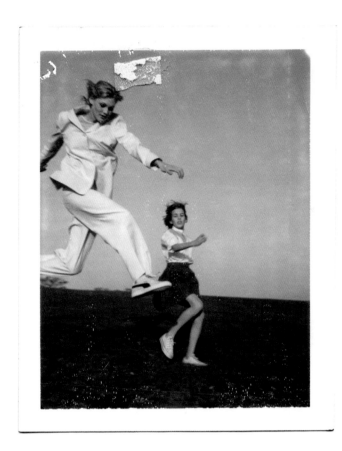

Shirley Mallmann & Nathalie Love, Malibu

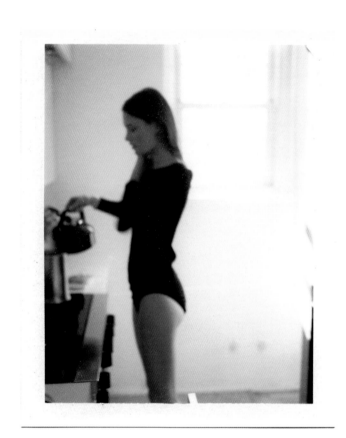

Shalom Harlow, New York

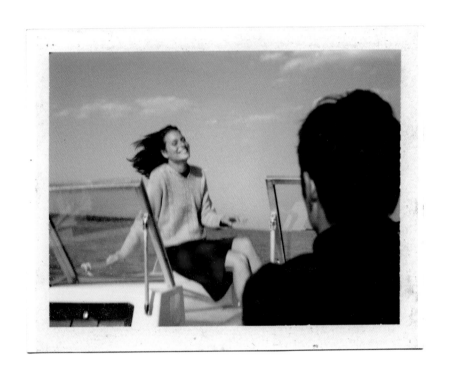

Sara Lamm, Montauk

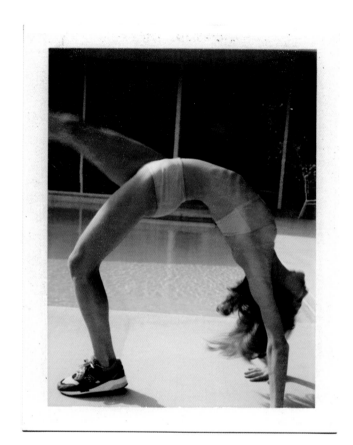

Kristina Semenovskaia, Bel Air

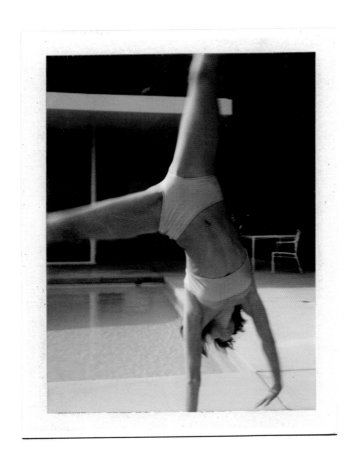

Kristina Semenovskaia, Bel Air

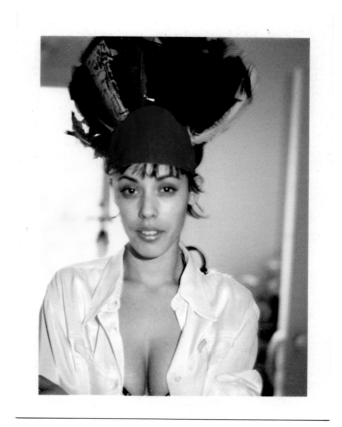

Josie Perez, Morgan House, Hollywood

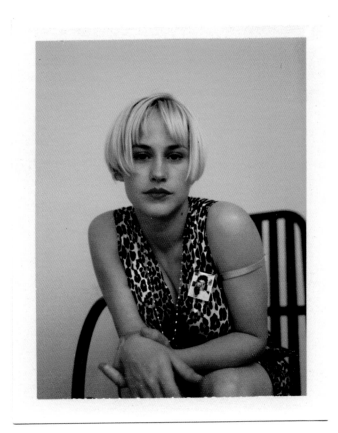

Patricia Arquette, Morgan House, Hollywood

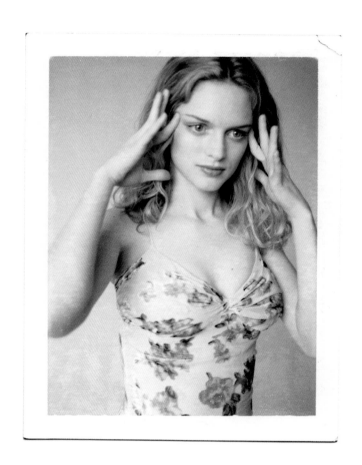

Heather Graham, Bel Air

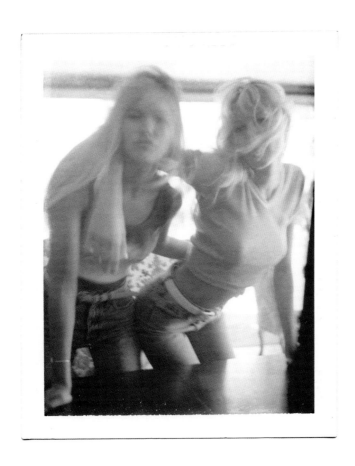

Ingrid Seynhaeve & Valeria Mazza, Diamond Head, Hawaii

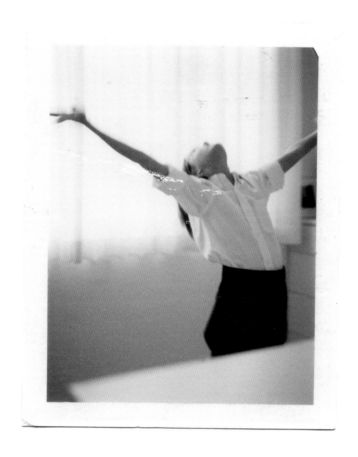

Nathalie Love, Stone Canyon

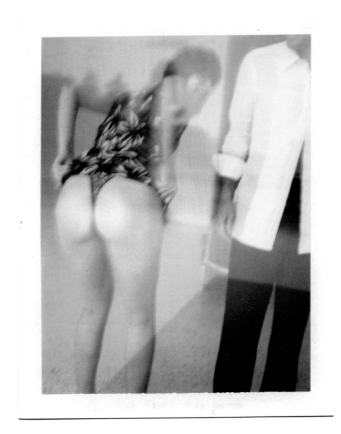

Nikki Uberti, Bel Air

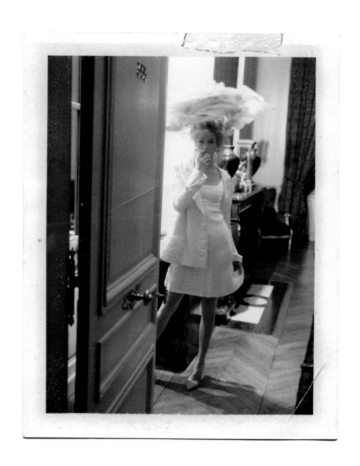

Meghan Douglas, Paris

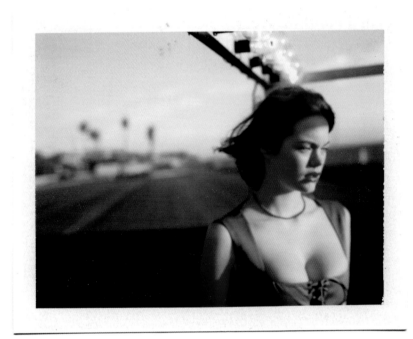

Jasmine Guinness, Zuma Beach

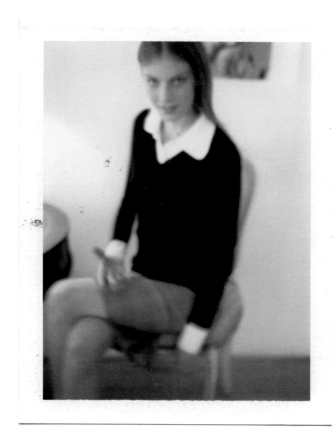

Angela Lindvall, Manhattan

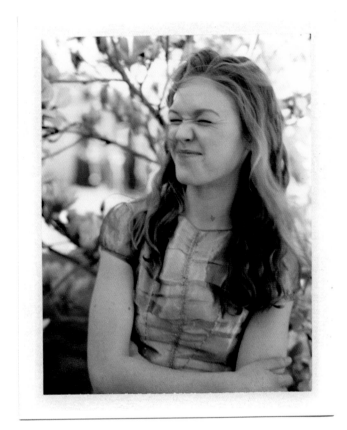

Julia Stiles, Morgan House, Hollywood

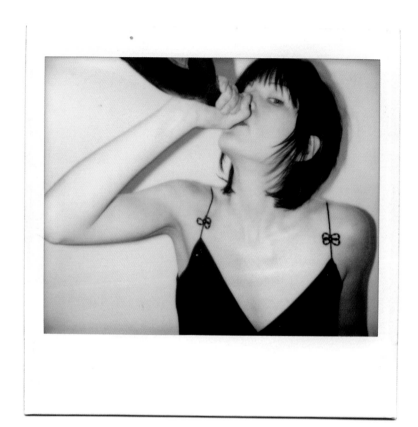

Nikki Uberti, Bel Air

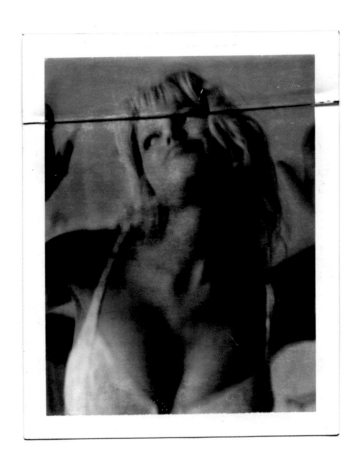

Ingrid Seynhaeve, Diamond Head, Hawaii

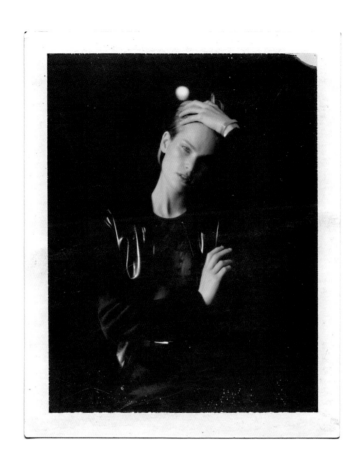

Meghan Douglas, New York

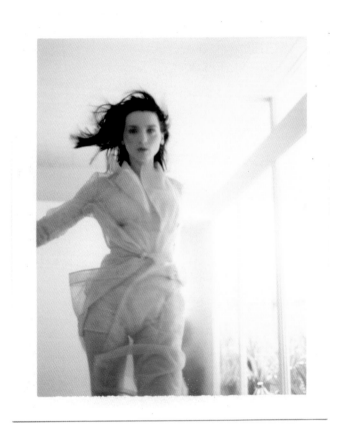

Michele Hicks, Wexler Steel House, Palm Springs

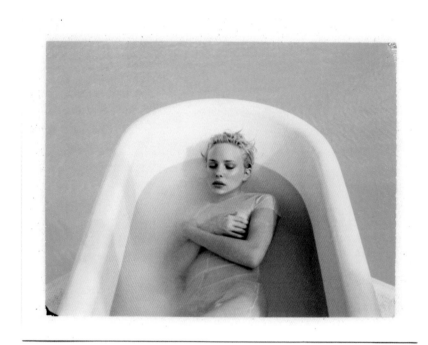

Jaime Rishar, Palm Springs

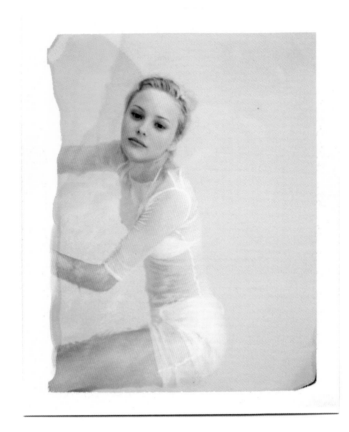

Jaime Rishar, Palm Springs

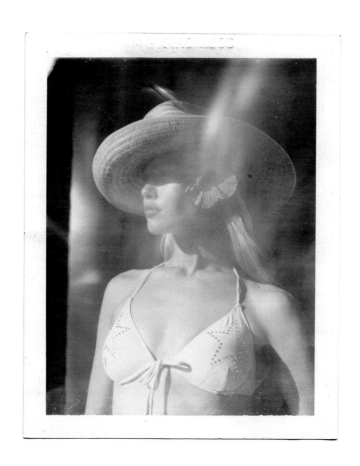

Valeria Mazza, Honolulu

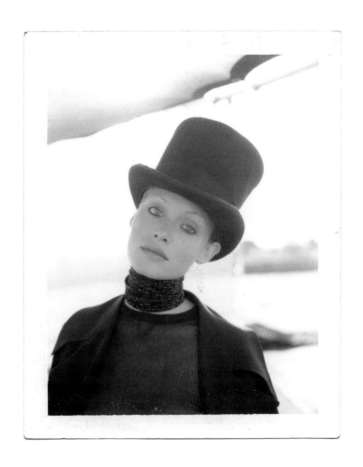

Amber Valletta, Joshua Tree

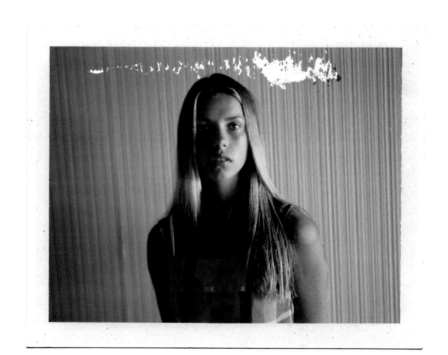

Missy Gibson, Laguna Beach

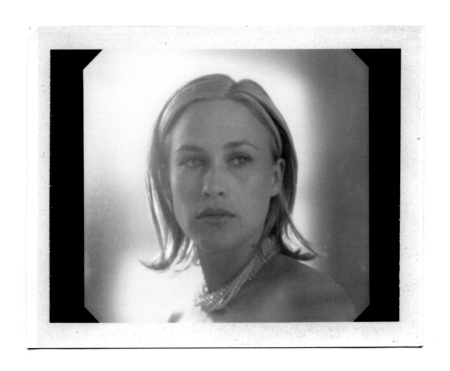

Patricia Arquette, Hollywood

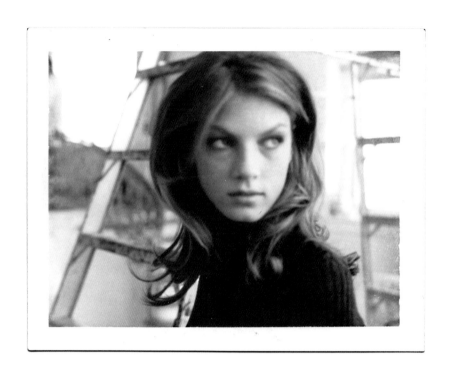

Angela Lindvall, New York

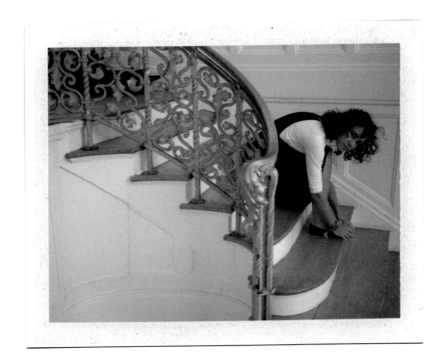

Lisa Eisner, New York

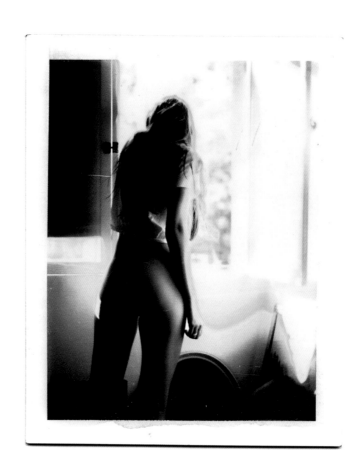

Morgan House, Hollywood

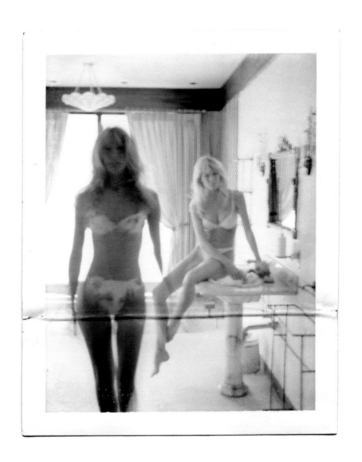

Ingrid Seynhaeve & Valeria Mazza, Kona

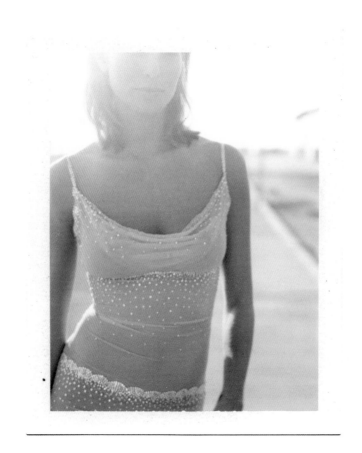

Niki Taylor, Miami Beach

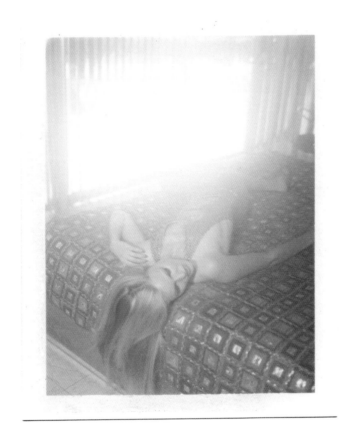

Anna Klevhag, Palm Springs

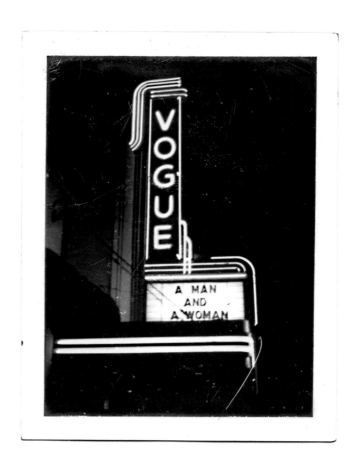

Pasadena

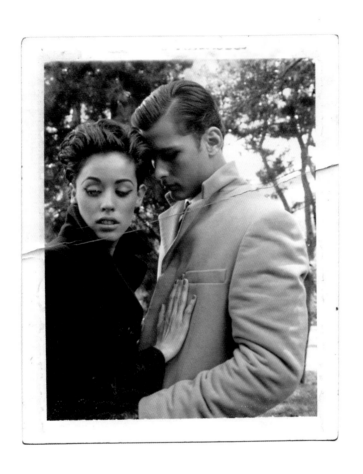

Josie Perez & Mark Fisher, Central Park

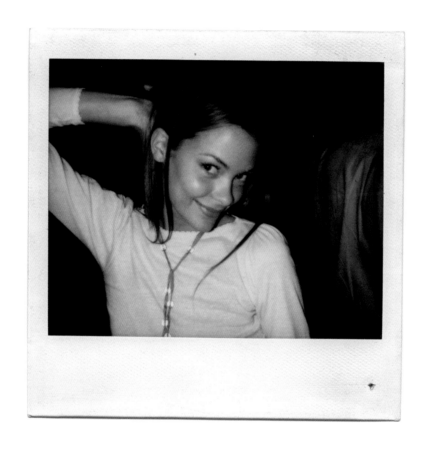

Jaime King, Beverly Hills

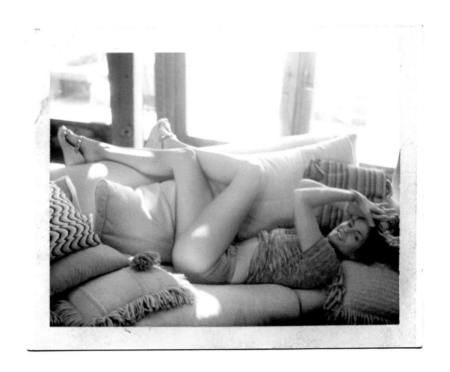

Cindy Crawford, Big Sur

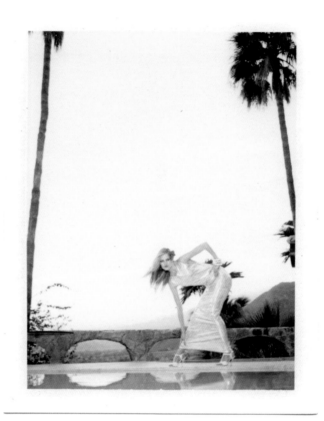

Anna Klevhag, Palm Springs

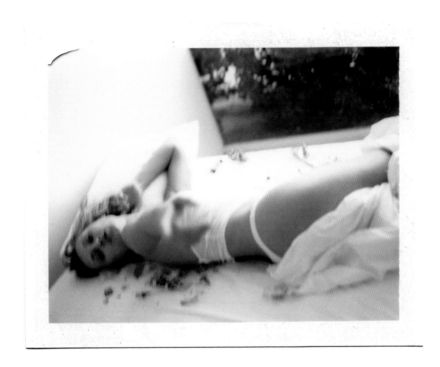

Ruza Madarevic, Wexler Steel House, Palm Springs

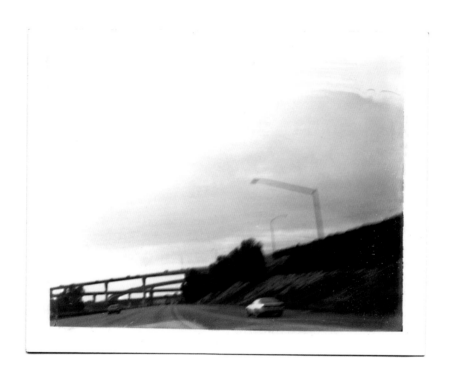

Pomona Freeway

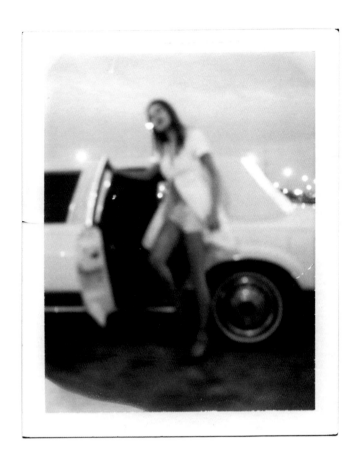

Milla Jovovich, LAX

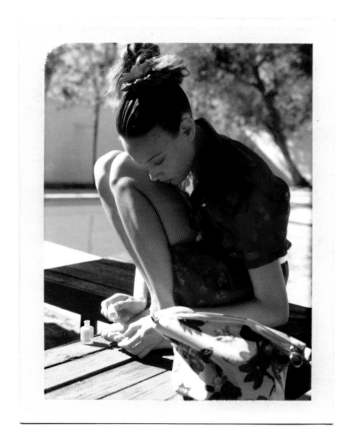

Nessie Gitlis-Graizon, Wexler Steel House, Palm Springs

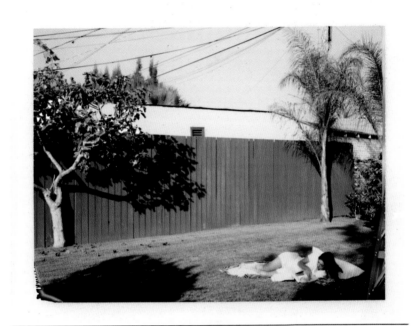

Sofia Coppola, Morgan House, Hollywood

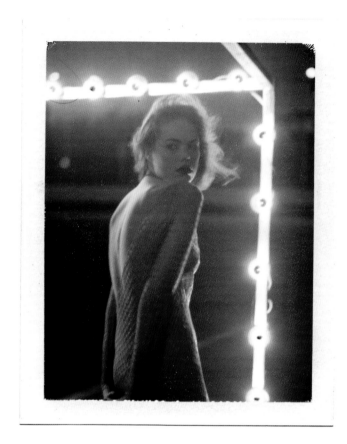

Jasmine Guinness, Zuma Beach

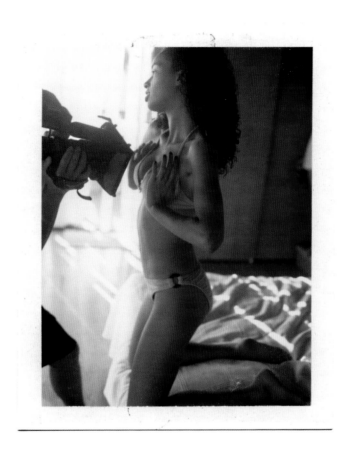

Brandi Quinones, Malibu

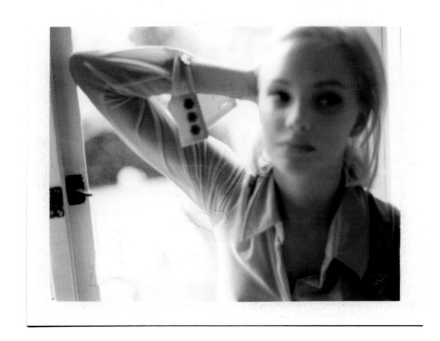

Jaime Rishar, Morgan House, Hollywood

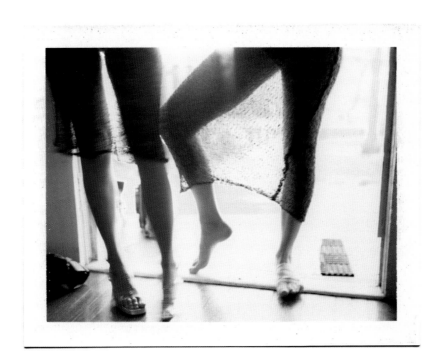

Silver Lake

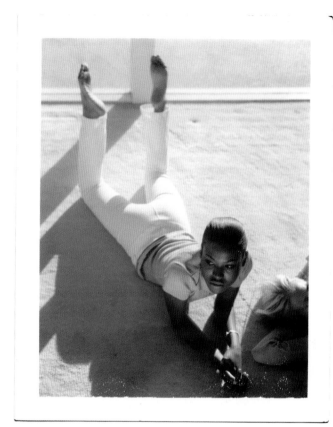

Nicola Vassell, Palm Springs

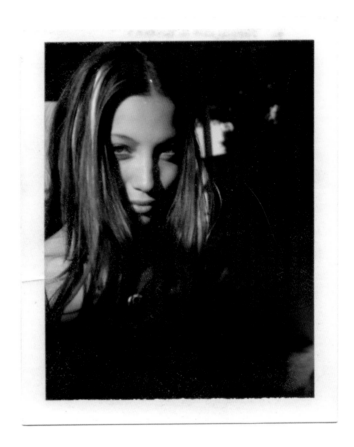

Nessie Gitlis-Graizon, Wexler Steel House, Palm Springs

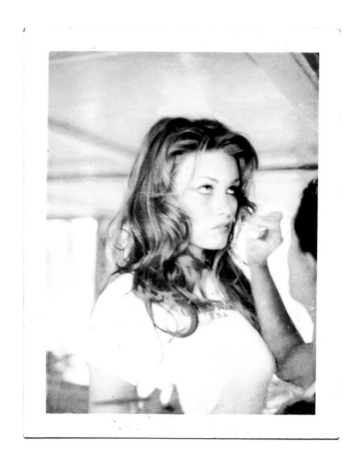

Larissa Bondarenko, Palm Springs

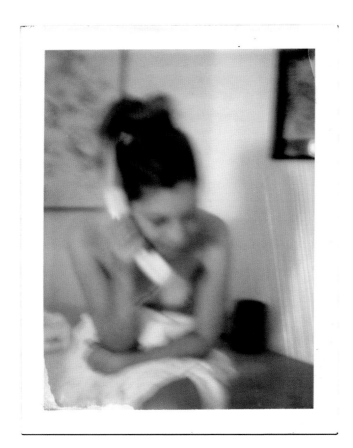

Sofia Coppola, Morgan House, Hollywood

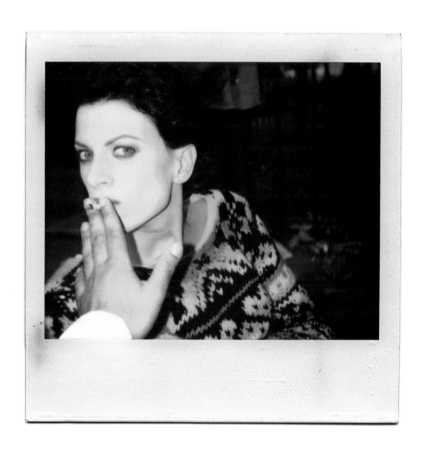

Kristen McMenamy, Greenwich Village, New York

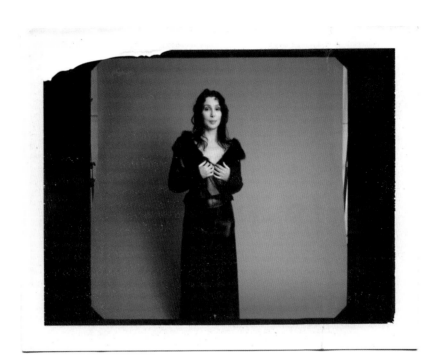

Cher, Hollywood

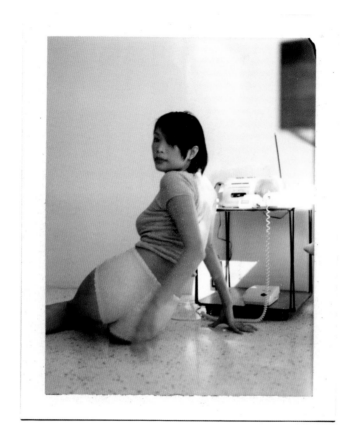

Navia Nguyen, Wexler Steel House, Palm Springs

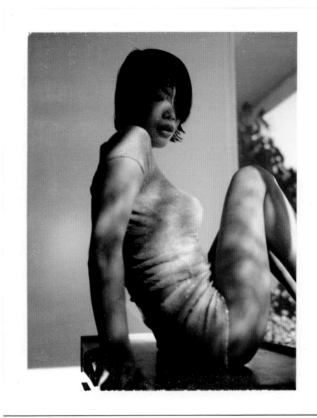

Navia Nguyen, Wexler Steel House, Palm Springs

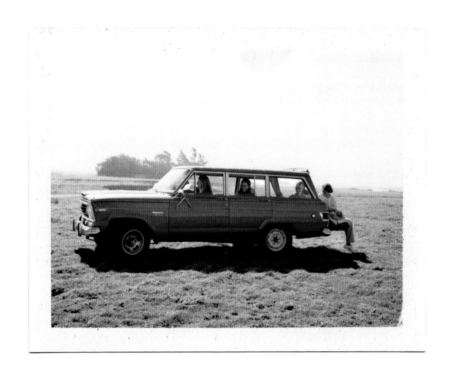

Cambria, California

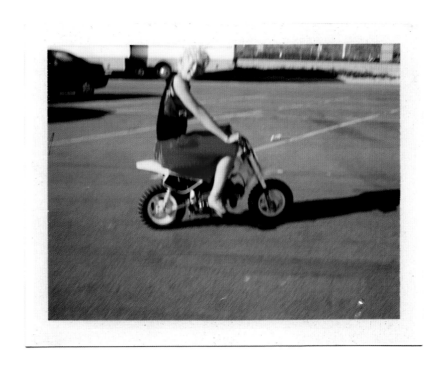

Jenna Elfman, Zuma Beach

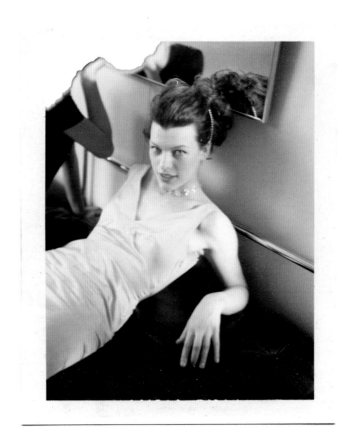

Milla Jovovich, New York

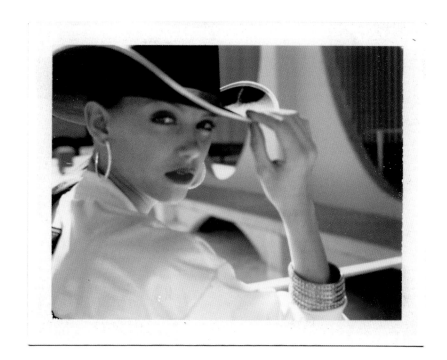

Leilani Bishop, Palm Springs

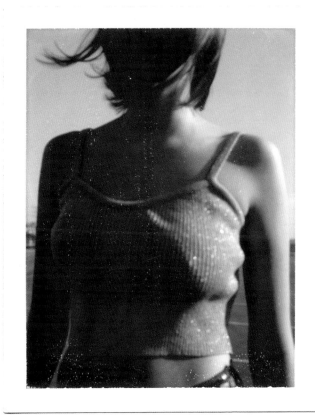

Jasmine Guinness, Zuma Beach

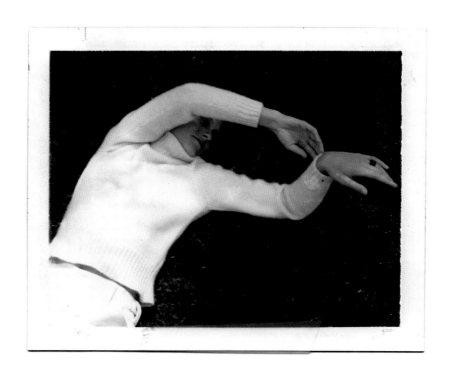

Sara Lamm, Montauk

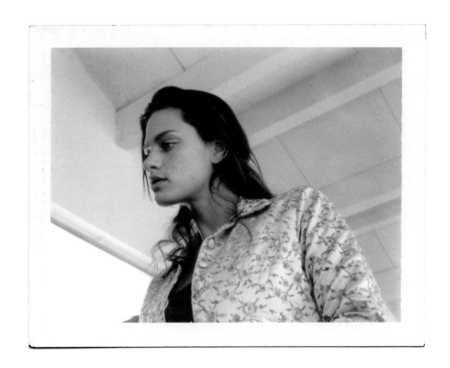

Pati Dubroff, Silver Lake

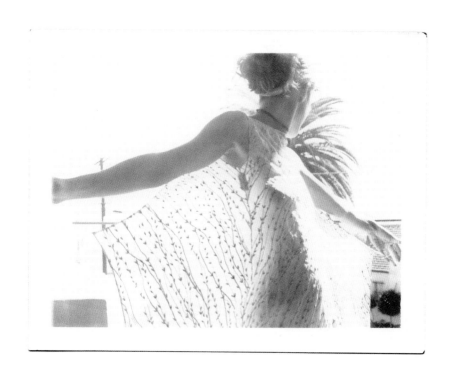

Jenny Levy, Silver Lake

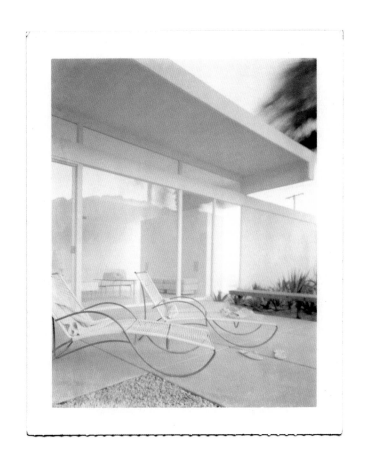

Donald Wexler Steel House, Palm Springs

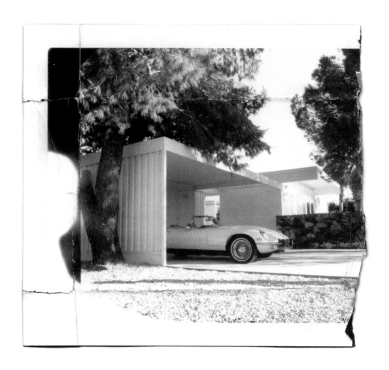

Donald Wexler Steel House, Palm Springs

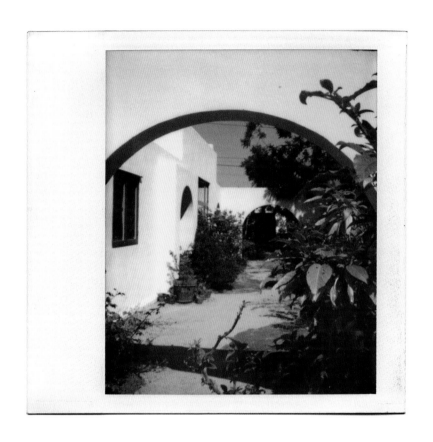

Irving Gill's Morgan House, Hollywood

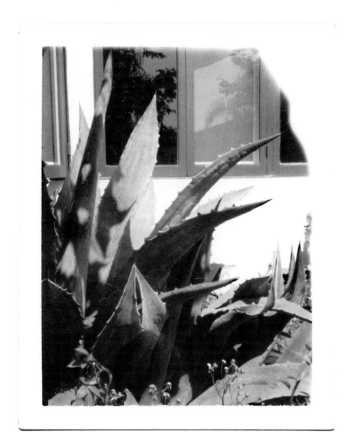

Irving Gill's Morgan House, Hollywood

ACKNOWLEDGEMENTS

Dedicated to Stephanie Nicks, the beautiful woman who shares her life with me.

A heartfelt thank you to Henry Wei Han whose support and assistance is treasured.

My gratitude goes out to the people who made this book possible. Tom Adler, Brad Dunning, Carol LeFlufy, Barrett Schultz, Mandy Zika, Mario Fuentes, and Merle Ginsberg.

To all the cherished collaborators who have invested their time, talent, and energy into the images of this book, I hope you find the memories as gorgeous and precious as I do.

First edition published by T. Adler Books, Santa Barbara

Copyright © 2018 Dewey Nicks

Copyright © 2018 Foreword by Brad Dunning

Design & edit by T. Adler Books

Research & production by Mandy Zika

Distributed by D.A.P. / Distributed Art Publishers

New York, New York, U.S.A.

Printed in China (ICLA)

ISBN 978-1-942884-34-7